The Event and Everydayness

Afterall Books

Henri Lefebvre

/

Julie Mehretu

TWO WORKS

The Everyday
and Everydayness

Henri Lefebvre

First published in
Yale French Studies 73 (1987) pp.7–11
Reprinted with their kind permission

Orient
(after D. Cherry,
post Irma
and summer)

Julie Mehretu

2017–2020
Ink and Acrylic on Canvas
274 × 305 cm (108 × 120 in)

Before the series of revolutions which ushered in what is called the modern era, housing, modes of dress, eating and drinking – in short, living – presented a prodigious diversity. Not subordinate to any one system, living varied according to region and country, levels and classes of the population, available natural resources, season, climate, profession, age and sex. This diversity has never been well acknowledged or recognised as such; it has resisted a rational kind of interpretation which has only come about in our own time by interfering with and destroying that diversity. Today we see a worldwide tendency to uniformity. Rationality dominates, accompanied but not diversified by irrationality; signs, rational in their way, are attached to things in order to convey the prestige of their possessors and their place in the hierarchy.

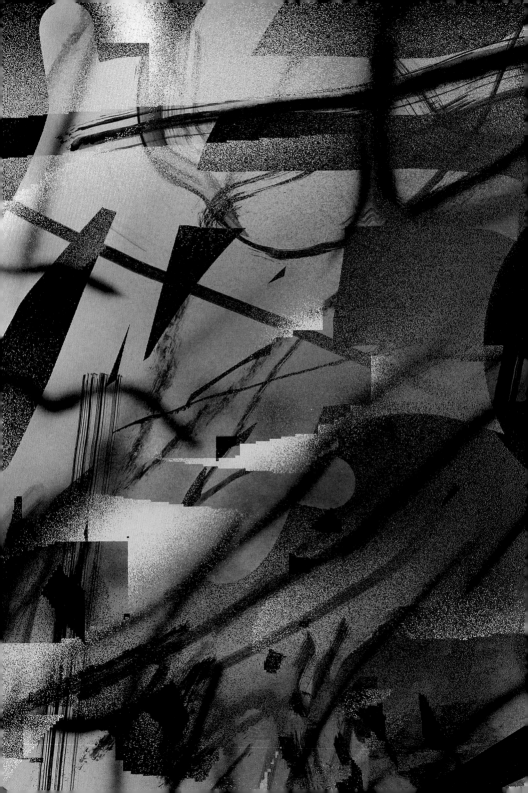

Forms,
functions

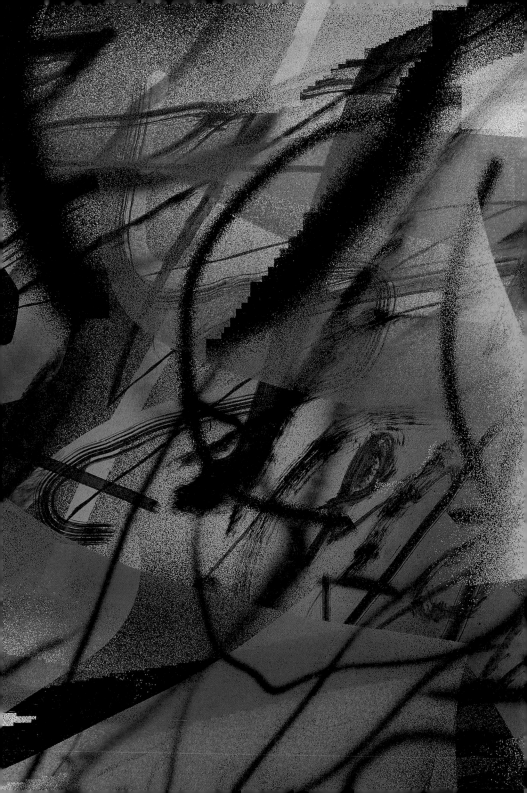

and
structures

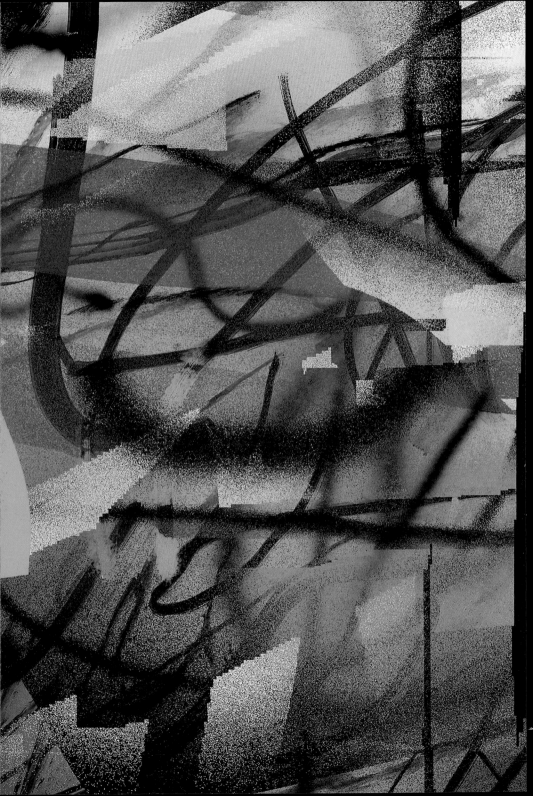

What has happened? There were, and there always have been forms, functions and structures. Things as well as institutions, 'objects' as well as 'subjects' offered up to the senses accessible and recognisable forms. People, whether individually or in groups, performed various functions, some of them physiological (eating, drinking, sleeping), others social (working, travelling). Structures, some of them natural and others constructed, allowed for the public or private performance of these functions, but with a radical – a root – difference: those forms, functions and structures were not known as such, not named. At once connected and distinct, they were part of an undifferentiated whole. Post-Cartesian analytic thought has often challenged these concrete 'totalities': every analysis of objective or social reality has come up with some residue resisting analysis, and the sum of such realities as seemed irreducible by human thought became a matter for infinite analysis, a reserve of divine thought. Every complex 'whole', from the smallest tool to the greatest works of art and learning, therefore possessed a symbolic value linking them to meaning at its most vast: to divinity and humanity, power and wisdom, good and evil, happiness and misery, the perennial and the ephemeral. These immense values were themselves mutable according to historical circumstance, to social classes, to rulers and mentors. Each object (an armchair just as much as a piece of clothing, a kitchen utensil as much as a house) was thus linked to some 'style' and therefore, as a work, contained while masking the larger functions and structures which were integral parts of its form.

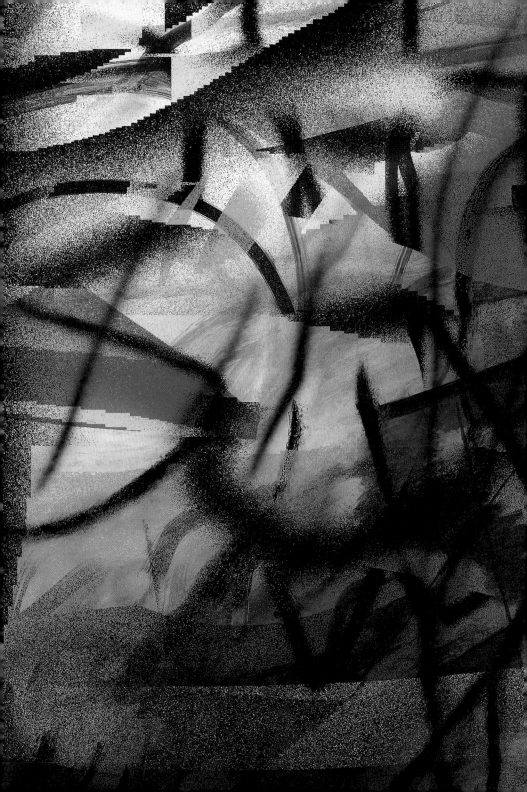

What happened to change the situation? The functional element was itself disengaged, rationalised, then industrially produced, and finally imposed by constraint and persuasion: that is to say, by means of advertising and by powerful economic and political lobbies. The relationship of form to function to structure has not disappeared. On the contrary, it has become a declared relationship, produced as such, more and more visible and readable, announced and displayed in a transparency of the three terms. A modern object clearly states what it is, its role and its place. This does not prevent its overstating or reproducing the signs of its meaningfulness: signs of satisfaction, of happiness, of quality, of wealth. From the modem armchair or coffee grinder to the automobile, the form-function-structure triumvirate is at once evident and legible.

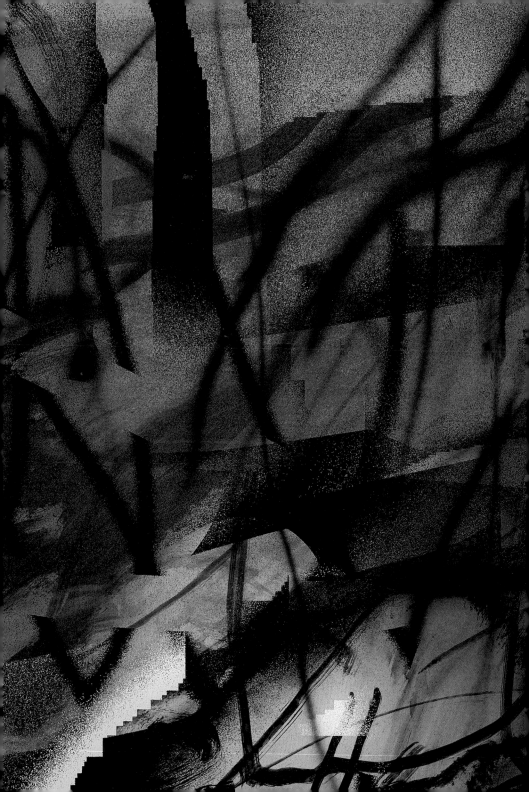

Within these parameters, there come to be constructed multiple systems or subsystems, each establishing in its own way a more or less coherent set of more or less durable objects. For example, in the domain of architecture, a variety of local, regional, and national architectural styles has given way to 'architectural urbanism,' a universalising system of structures and functions in supposedly rational geometric forms. The same thing is true of industrially produced food: a system groups products around various functionally specific household appliances such as the refrigerator, freezer, electric oven etc. And of course the totalising system that has been constructed around the automobile seems ready to sacrifice all of society to its dominion. It so happens that these systems and subsystems tend to deteriorate or blow out. Are even the days of car travel numbered?

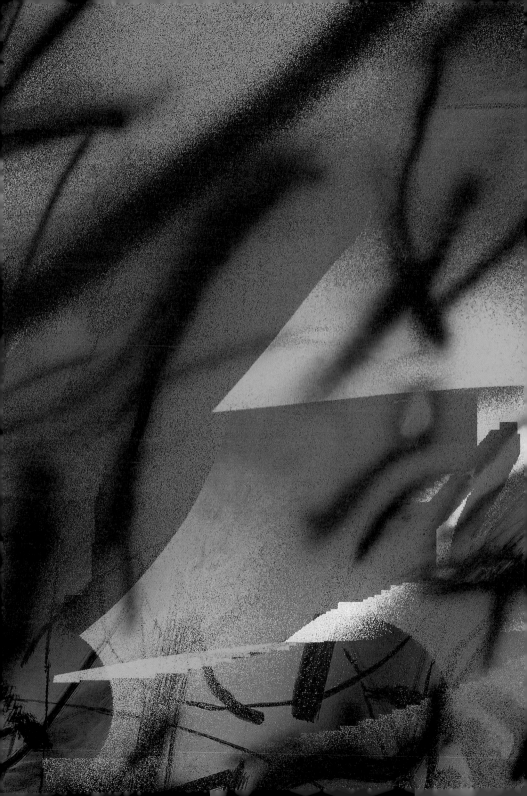

Whatever the case may be, housing, fashion and food have tended and still tend to constitute autonomous subsystems, closed off from one another. Each of them appears to present as great a diversity as the old modes of living of the premodern era. This diversity is only apparent. It is only arranged. Once the dominant forces making it possible for these elements to combine with one another is understood, the artificial mechanism of their grouping is recognised and the fatuousness of their diversity becomes intolerable. The system breaks down.

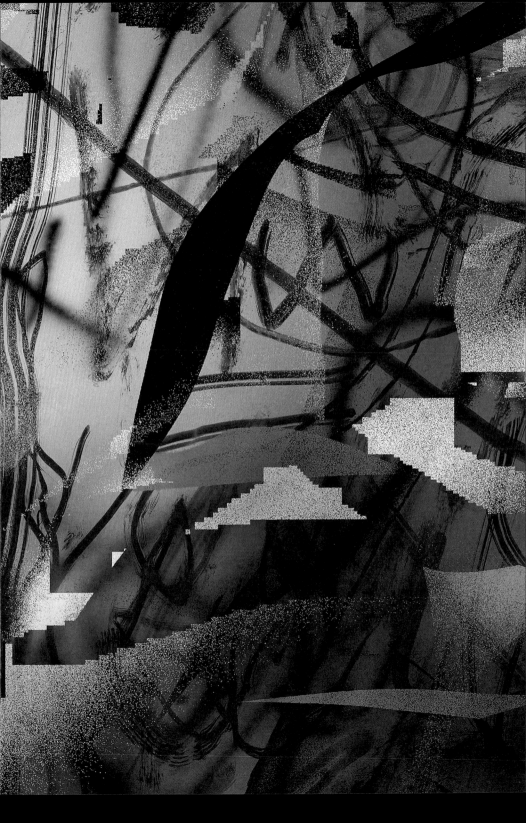

All such systems have in common a general law of functionalism. The everyday can therefore be defined as a set of functions which connect and join together systems that might appear to be distinct. Thus defined, the everyday is a product, the most general of products in an era where production engenders consumption, and where consumption is manipulated by producers: not by 'workers', but by the managers and owners of the means of production (intellectual, instrumental, scientific). The everyday is therefore the most universal and the most unique condition, the most social and the most individuated, the most obvious and the best hidden. A condition stipulated for the legibility of forms, ordained by means of functions, inscribed within structures, the everyday constitutes the platform upon which the bureaucratic society of controlled consumerism is erected.

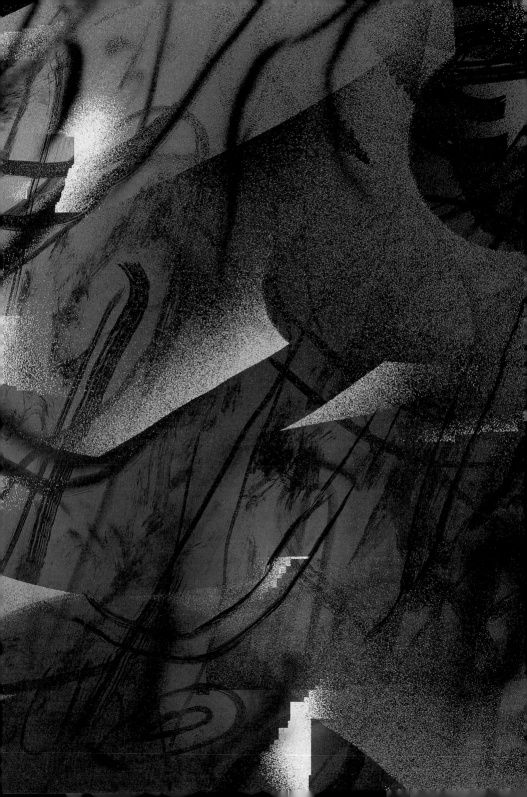

A
common

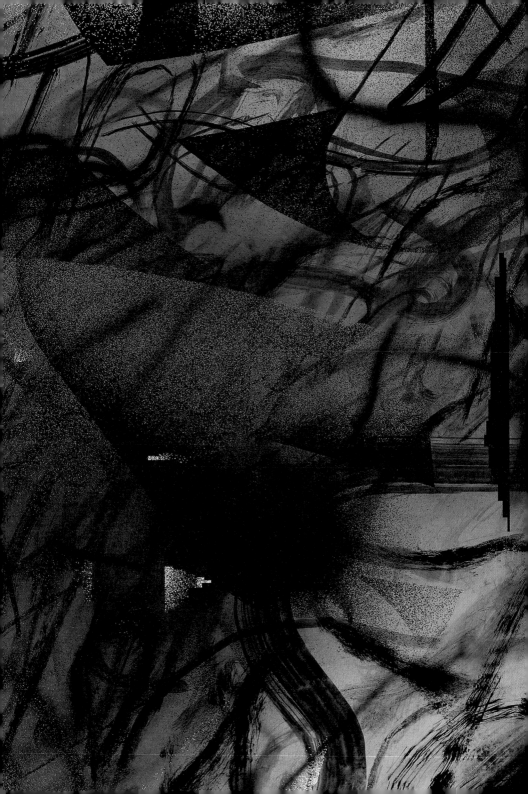

denominator

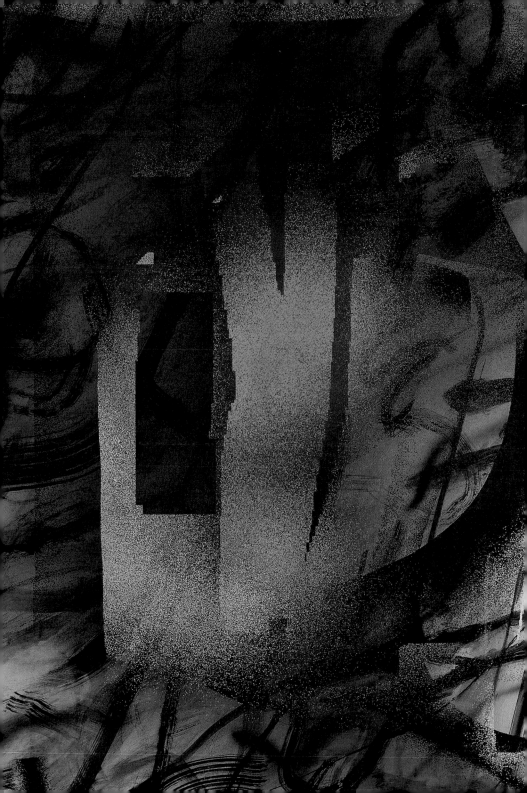

The everyday is therefore a concept. In order for it to have ever been engaged as a concept, the reality it designated had to have become dominant, and the old obsessions about shortages – 'Give us this day our daily bread...' – had to disappear. Until recently, things, furniture and buildings were built one by one, and each existed in relation to accepted moral and social references, to symbols. From the twentieth century onward, all these references collapse, including the greatest and oldest figure of them all, that of the Father (eternal or temporal, divine or human). How can we grasp this extraordinary and still so poorly understood configuration of facts? The collapse of the referent in morality, history, nature, religion, cities, space; the collapse even of perspective in its classical spatial sense or the collapse of tonality in music... Abundance – a rational, programmed abundance and planned obsolescence – replacing shortage in the first world; destructive colonisation of the third world and finally of nature itself... The prevalence of signs; omnipresent war and violence; revolutions which follow one after another only to be cut short or to turn back against themselves...

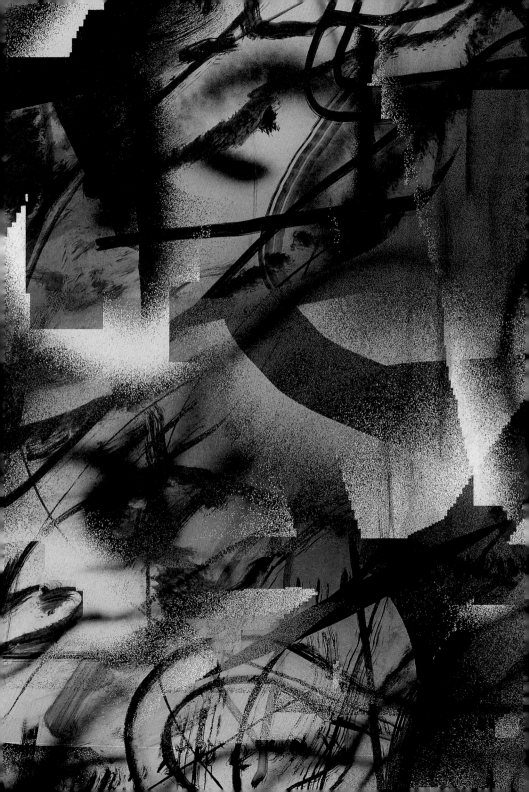

The everyday, established and consolidated, remains a sole surviving common sense referent and point of reference. 'Intellectuals', on the other hand, seek their systems of reference elsewhere: in language and discourse, or sometimes in a political party. The proposition here is to decode the modern world, that bloody riddle, according to the everyday.

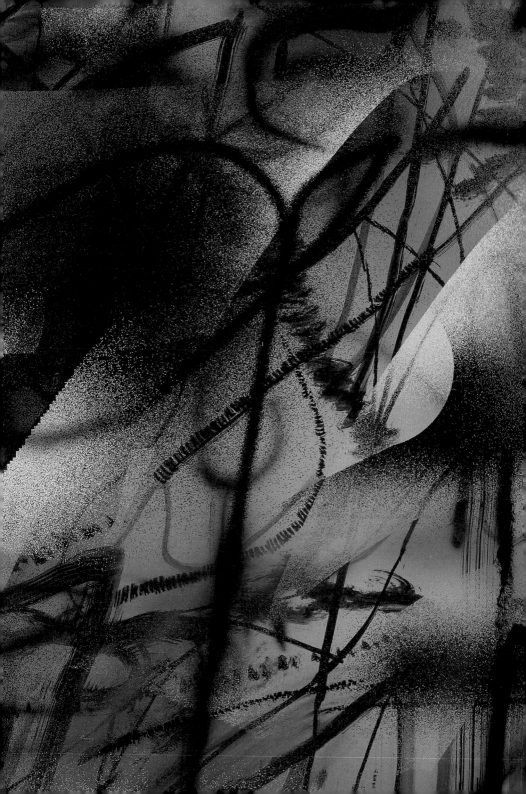

The concept of everydayness does not therefore designate a system, but rather a denominator common to existing systems including judicial, contractual, pedagogical, fiscal and police systems. Banality? Why should the study of the banal itself be banal? Are not the surreal, the extraordinary, the surprising, even the magical, also part of the real? Why wouldn't the concept of everydayness reveal the extraordinary in the ordinary?

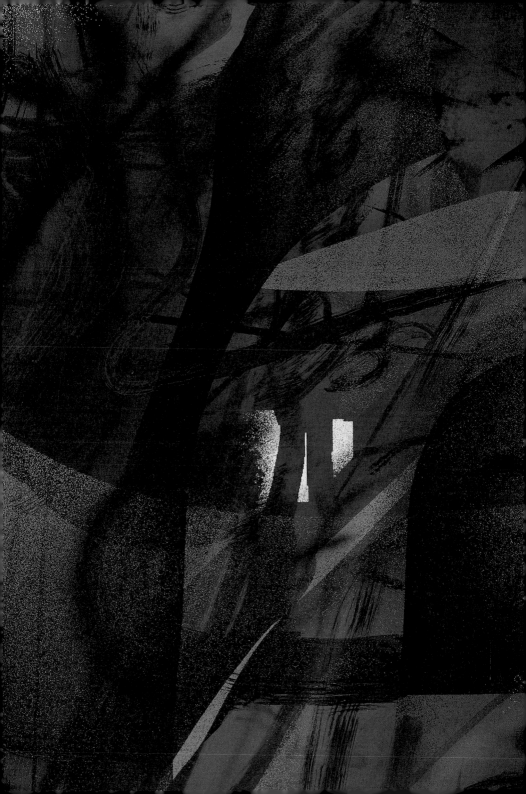

Repetition

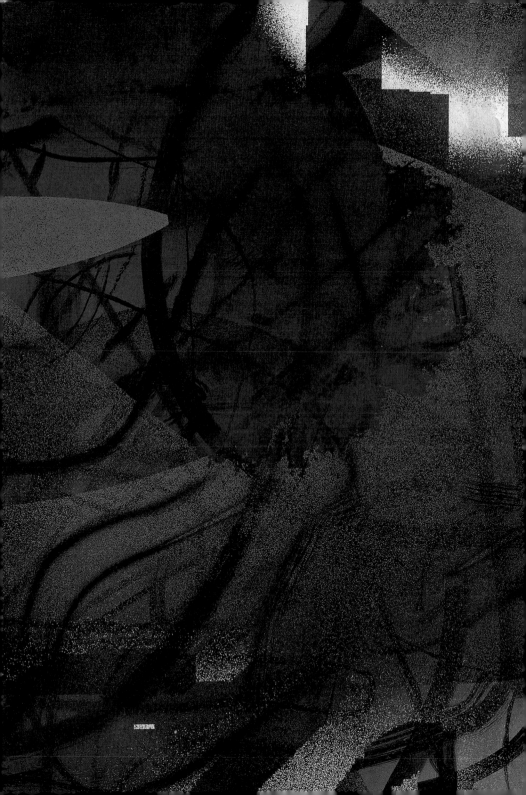

and change

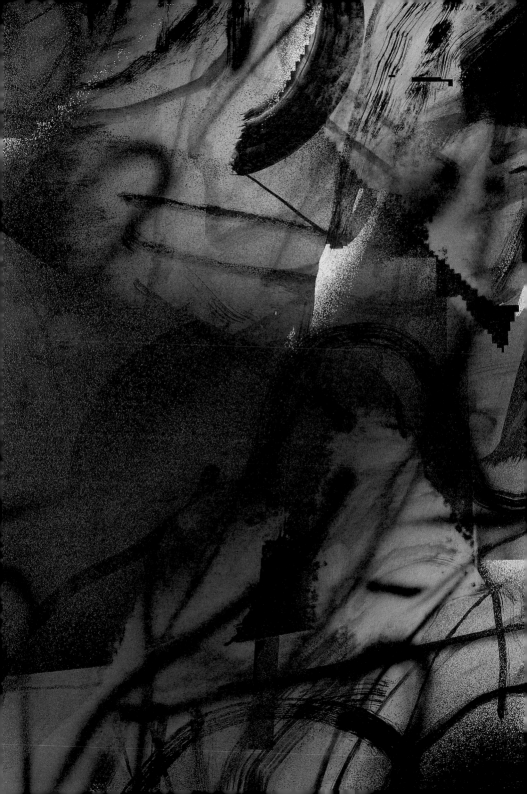

Thus formulated, the concept of the everyday illuminates the past. Everyday life has always existed, even if in ways vastly different from our own. The character of the everyday has always been repetitive and veiled by obsession and fear. In the study of the everyday we discover the great problem of repetition, one of the most difficult problems facing us. The everyday is situated at the intersection of two modes of repetition: the cyclical, which dominates in nature, and the linear, which dominates in processes known as 'rational'. The everyday implies on the one hand cycles, nights and days, seasons and harvests, activity and rest, hunger and satisfaction, desire and its fulfilment, life and death, and it implies on the other hand the repetitive gestures of work and consumption.

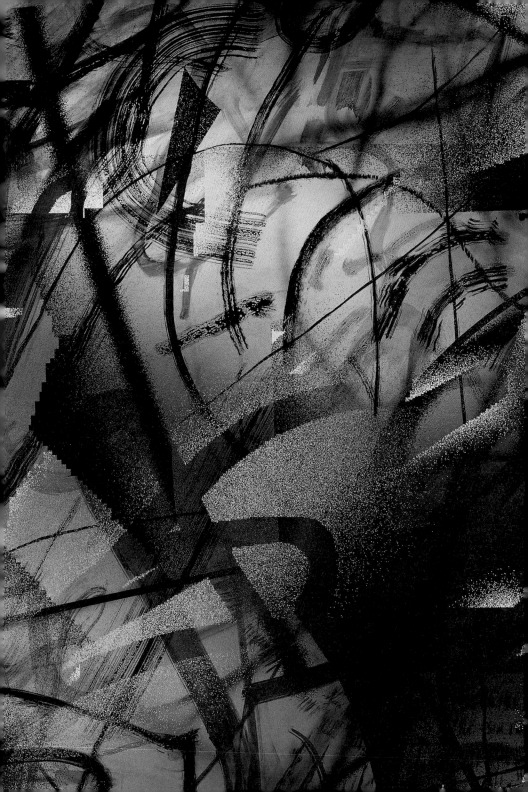

In modern life, the repetitive gestures tend to mask and to crush the cycles. The everyday imposes its monotony. It is the invariable constant of the variations it envelops. The days follow one after another and resemble one another, and yet – here lies the contradiction at the heart of everydayness – everything changes. But the change is programmed: obsolescence is planned. Production anticipates reproduction; production produces change in such a way as to superimpose the impression of speed onto that of monotony. Some people cry out against the acceleration of time, others cry out against stagnation. They're both right.

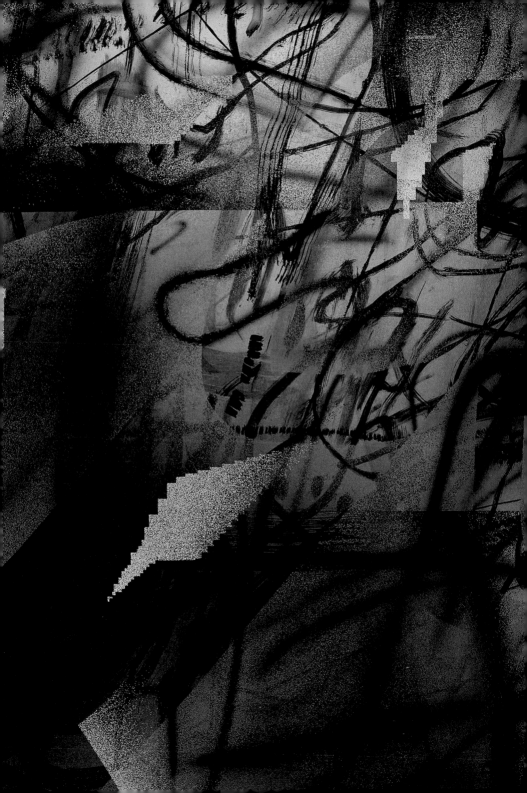

General
and
diversified

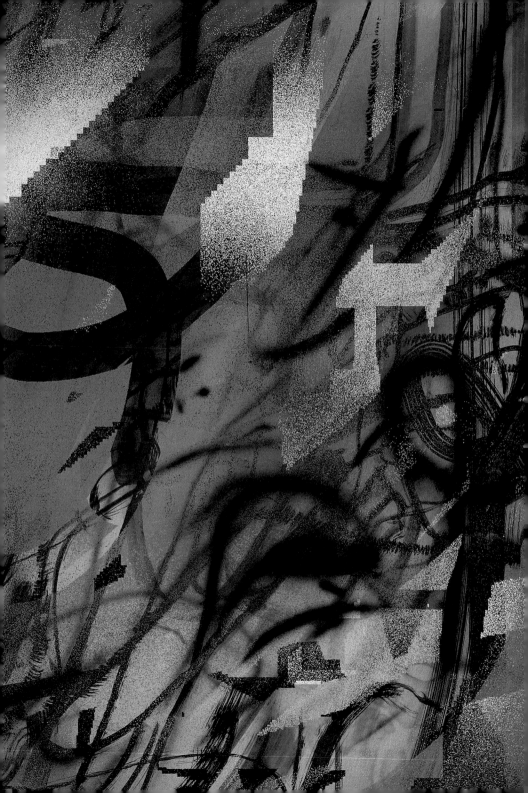

passivity

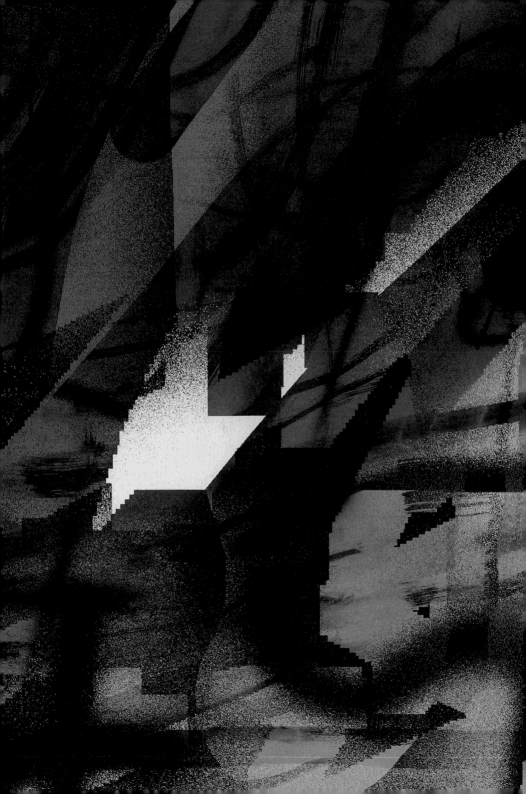

Common denominator of activities, locus and milieu of human functions, the everyday can also be analysed as the uniform aspect of the major sectors of social life: work, family, private life, leisure. These sectors, though distinct as forms, are imposed upon in their practice by a structure allowing us to discover what they share: organised passivity. This means, in leisure activities, the passivity of the spectator faced with images and landscapes; in the workplace, it means passivity when faced with decisions in which the worker takes no part; in private life, it means the imposition of consumption, since the available choices are directed and the needs of the consumer created by advertising and market studies. This generalised passivity is moreover distributed unequally. It weighs more heavily on women, who are sentenced to everyday life, on the working class, on employees who are not technocrats, on youth – in short on the majority of people – yet never in the same way, at the same time, never all at once.

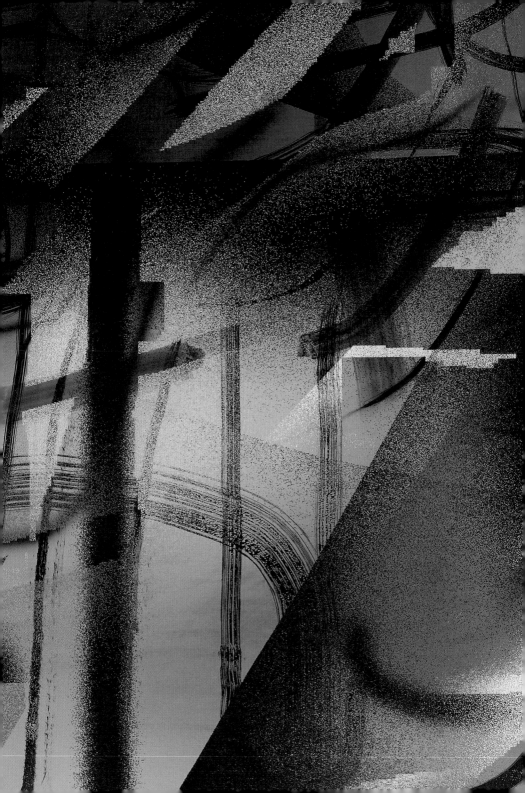

Modernity

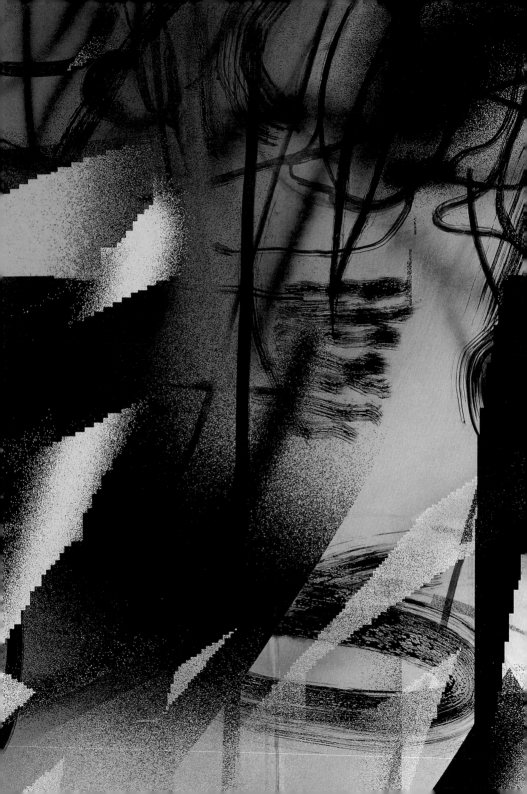

The everyday is covered by a surface: that of modernity. News stories and the turbulent affectations of art, fashion and event veil without ever eradicating the everyday blahs. Images, the cinema and television divert the everyday by at times offering up to it its own spectacle, or sometimes the spectacle of the distinctly non-everyday; violence, death, catastrophe, the lives of kings and stars – those who we are led to believe defy everydayness. Modernity and everydayness constitute a deep structure that a critical analysis can work to uncover.

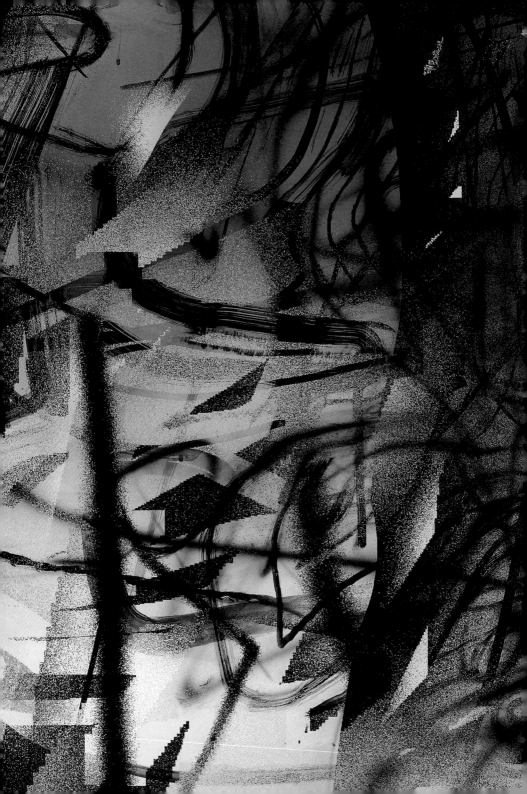

Such a critical analysis of the everyday has itself been articulated in several conflicting ways. Some treat the everyday with impatience; they want to 'change life' and do it quickly; they want it all and they want it now! Others believe that lived experience is neither important nor interesting, and that instead of trying to understand it, it should be minimised, bracketed, to make way for science, technology, economic growth, etc.

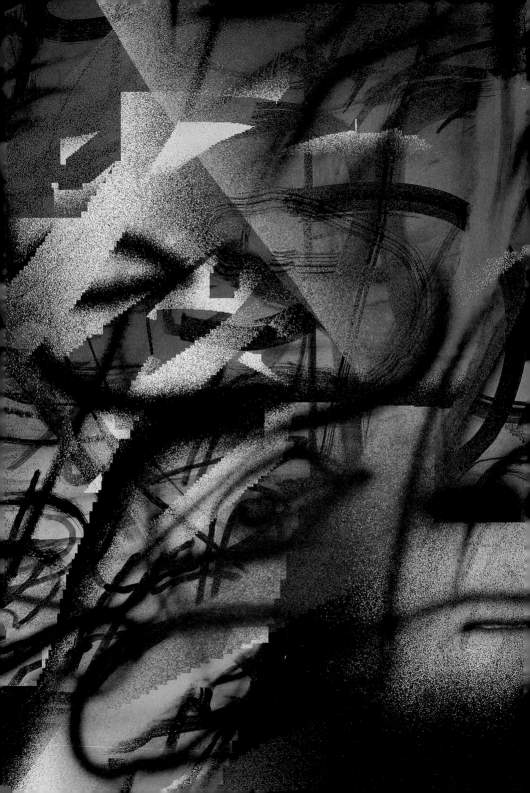

To the former, we might reply that transforming the everyday requires certain conditions. A break with the everyday by means of festival – violent or peaceful – cannot endure. In order to change life, society, space, architecture, even the city must change. To the latter, we might reply that it is monstrous to reduce 'lived experience', that a recognition of the inadequacy of pious humanism does not authorise the assimilation of people to insects. Given the colossal technical means at our disposal and the terrifying dangers which lie in wait for us, we would risk, in that case, abandoning humanism only to enter into 'superhumanism'.

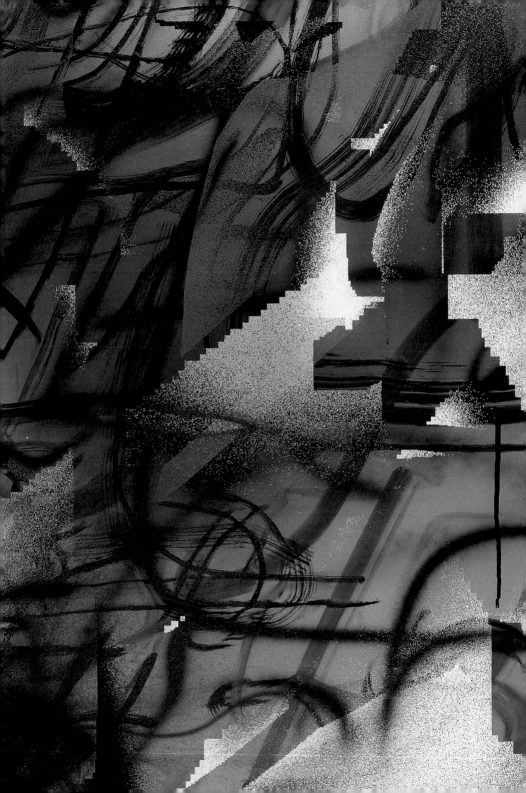

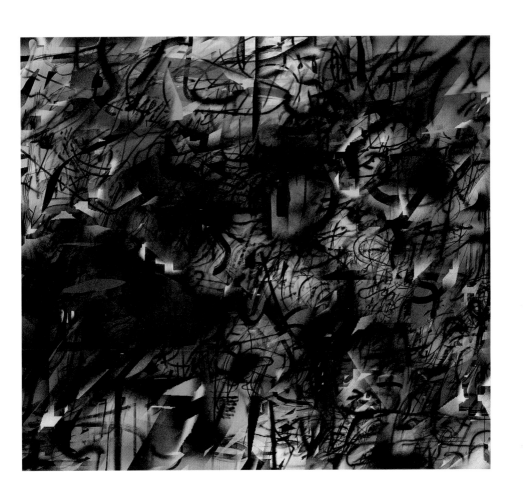

Julie Mehretu
Orient (after D. Cherry, post Irma and summer)
2017–2020
Ink and Acrylic on Canvas
274 × 305 cm (108 × 120 in)

SAY THEIR NAMES

Marvin Scott III	Breonna Taylor	Marcus-David Peters
Jenoah Donald	Barry Gedeus	Dorian Harris
Patrick Warren	Manuel Ellis	Danny Ray Thomas
Xzavier Hill	Ahmaud Arbery	Stephon Clark
Bennie Edwards	Lionel Morris	Ronell Foster
Casey Goodson Jr.	Jaquyn O'Neill Light	Damon Grimes
Aiden Ellison	William Green	James Lacy
Quawan Charles	Darius Tarver	Charleena Lyles
Walter Wallace Jr.	Miciah Lee	Mikel McIntyre
Jonathan Price	John Neville	Jordan Edwards
Kurt Reinhold	Michael Dean	Timothy Caughman
Dijon Kizzee	Atatiana Jefferson	Alteria Woods
Damian Daniels	Byron Williams	Desmond Phillips
Anthony McClain	Elijah McClain	Deborah Danner
Julian Lewis	Jaleel Medlock	Alfred Olango
Maurice Abisdid-Wagner	Dominique Clayton	Terence Crutcher
Rayshard Brooks	Pamela Turner	Christian Taylor
Priscilla Slater	Ronald Greene	Jamarion Robinson
Robert Forbes	Sterling Higgins	Donnell Thompson Jr.
Kamal Flowers	Bradley Blackshire	Joseph Mann
Jamel Floyda	Jassmine McBride	Philando Castile
David McAtee	Aleah Jenkins	Alton Sterling
James Scurlock	Emantic Bradford Jr.	Jay Anderson Jr.
Calvin Horton Jr.	Jemel Roberson	David Joseph
Tony McDade	Charles Roundtree Jr.	Antronie Scott
Dion Johnson	Botham Jean	Bettie Jones
George Floyd	Harith Augustus	Quintonio Legrier
Maurice Gordon	Jason Washington	Corey Jones
Cornelius Fredericks	Antwon Rose Jr.	Samuel Dubose
Steven Taylor	Robert White	Darrius Stewart
Daniel Prude	Earl McNeil	Sandra Bland

Susie Jackson
Daniel Simmons
Ethel Lance
Myra Thompson
Cynthia Hurd
Depayne Middleton-Doctor
Sharonda Coleman-Singleton
Clementa Pinckney
Tywanza Sanders
Kalief Browder
Freddie Gray
Norman Cooper
Walter Scott
Natasha McKenna
Rumain Brisbon
Tamir Rice
Akai Gurley
Tanisha Anderson
Laquan McDonald
Cameron Tillman
Darrien Hunt
Michael Brown
Kajieme Powell
Michelle Cusseaux
Dante Parker
Ezell Ford
Amir Brooks
John Crawford III
Eric Garner
Jerry Dwight Brown
Victor White III

Marquise Jones
Yvette Smith
Renisha McBride
Jonathan Ferrell
Deion Fludd
Gabriel Winzer
Wayne A. Jones
Kimani Gray
Kayla Moore
Corey Stingley
Darnesha Harris
Jordan Davis
Mohamed Bah
Sgt. James Brown
Darius Simmons
Rekia Boyd
Trayvon Martin
Willie Ray Banks
Kenneth Chamberlain Sr.
Cletis Williams
Robert Ricks
Eugene Ellison
Danroy 'DJ' Henry Jr.
Aiyana Stanley-Jones
Lawrence Allen
Oscar Grant
Julian Alexander
Marvin Parker
Deaunta Farrow
Sean Bell
Kathryn Johnston

Timothy Stansbury Jr.
Alberta Spruill
Anthony Dwain Lee
Ricky Byrdsong
Amadou Diallo
James Byrd Jr.
Nicholas Heyward Jr.
Mary Mitchell
Sharon Walker
Eleanor Bumpurs
Edward Gardner
Elton Hayes
Fred Hampton
Martin Luther King Jr.
Alberta Odell Jones
Jimmie Lee Jackson
James Earl Chaney
Louis Allen
Medgar Evers
Herbert Lee
John Earl Reese
Emmett Till
William McDuffie
Della McDuffie
Malcolm Wright
George Stinney Jr.
Dr. Andrew C. Jackson

and so many other lives that
were taken

JULIE MEHRETU /
HENRI LEFEBVRE

*THE EVERYDAY AND
EVERYDAYNESS*

ISBN 978-3-96098-902-8

First published in 2021 by
Afterall Books, London
and Koenig Books, London

Afterall
Central Saint Martins
University of the Arts London
Granary Building
1 Granary Square
London N1C 4AA
afterall.org

Afterall is a Research Centre of
University of the Arts London,
located in Central Saint Martins

Editors
 Amber Husain, Mark Lewis
Project Coordinator
 Beth Bramich
Project Manager
 Chloe Ting
Editorial Director
 Mark Lewis
Associate Director
 Charles Esche
Design
 Ben Weaver Studio
Photography
 Tom Powel Imaging
Cover Design
 Pacific
 pacificpacific.pub

Printed & bound by die Keure,
Belgium

DISTRIBUTION

Germany, Austria, Switzerland
/ Europe:
Buchhandlung Walther König
Ehrenstr. 4,
D–50672 Köln
49 (0) 221 / 20 59 6 53
verlag buchhandlung-walther-
koenig.de

United States & Canada:
D.A.P. / Distributed Art
Publishers, Inc.
75 Broad Street, Suite 630
USA–New York, NY 10004
1 (0) 212 627 1999
dapinc.com

Outside Germany, Austria &
Switzerland, the United States
& Canada:
Thames & Hudson Ltd., London
thamesandhudson.com